There may be hundreds of cities named Santa Cruz (translation: Holy Cross) around the world, I've never counted, but the two most close to my heart are in California and New Mexico. Like any village, town, or city, or, for that matter any place on Earth, they are filled with shadows. Mysterious as these shadows be, they pose little threat and project from objects obstructing the light. One then might wonder why, then, my subject is an ordinary sheet, not an extraordinary mountain, tree, or thee. I have no answer except that it provokes me. I should add here, that none of the enclosed photographs, as with my other published collections, have been posed in any way, or the resulting photos altered in the slightest. I am much more interested in what the universe offers me than vice versa.

The Shadows Of Santa Cruz

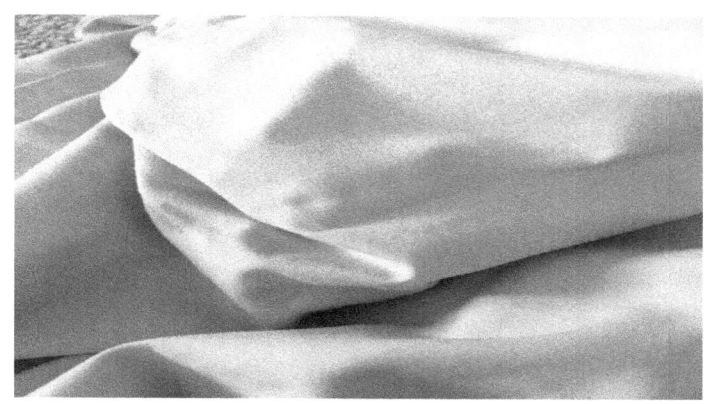

Photographs By David Cope

The Shadows of Santa Cruz
Photographs by David Cope

Epoc Books
Printed in the United States of America
© David Cope 2016
All Rights Reserved.
Published 2012.

The characters and events in this book are fictitious.
Any similarity to real persons, living or dead, is coincidental
and not intended by the author.

This book is dedicated to my wife, sons, and grandchildren, Zoe, Tess, Gavin, and Ethan whose excitement for everyday things never ceases to amaze me. And to those older kids like me who believe in those children.

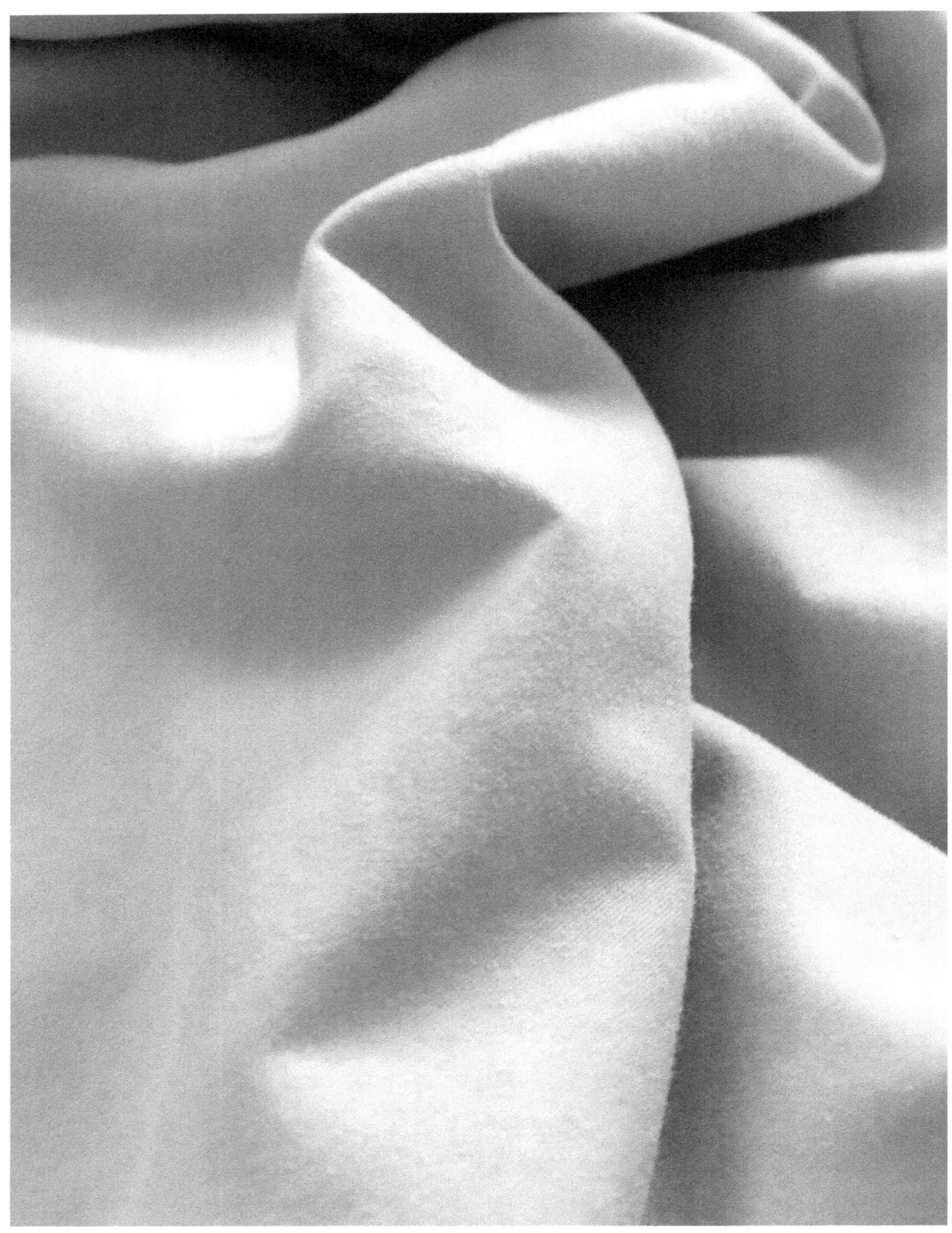

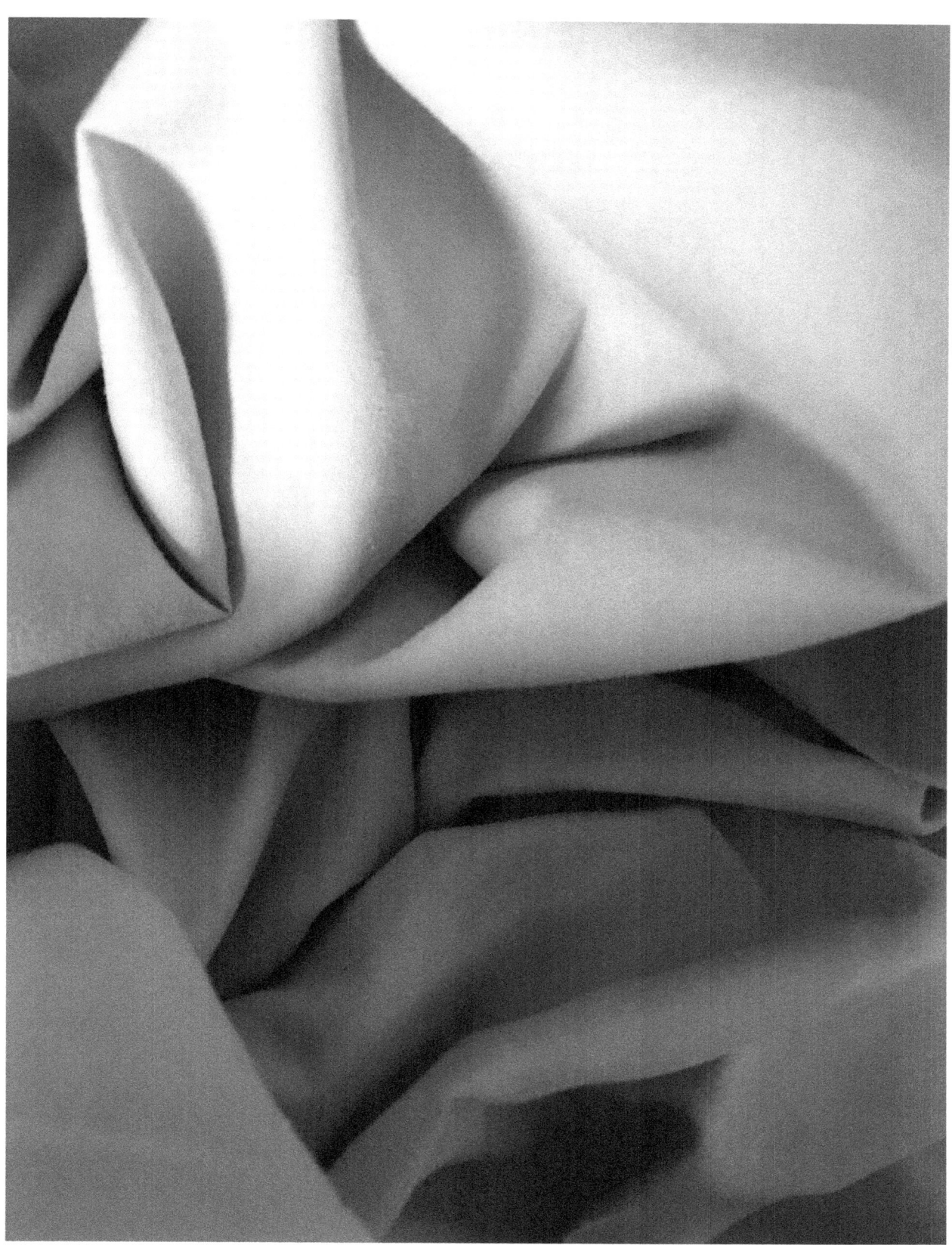

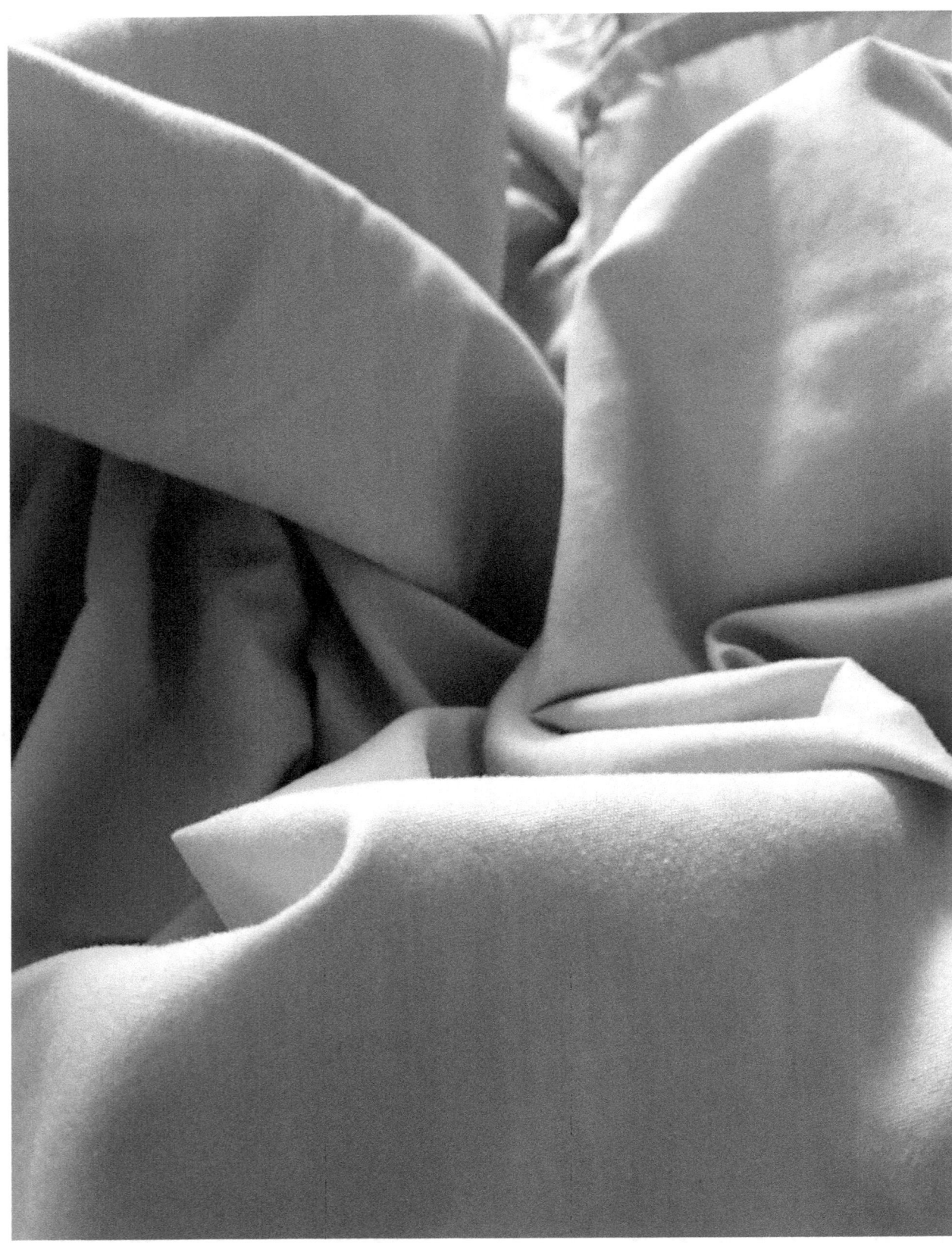

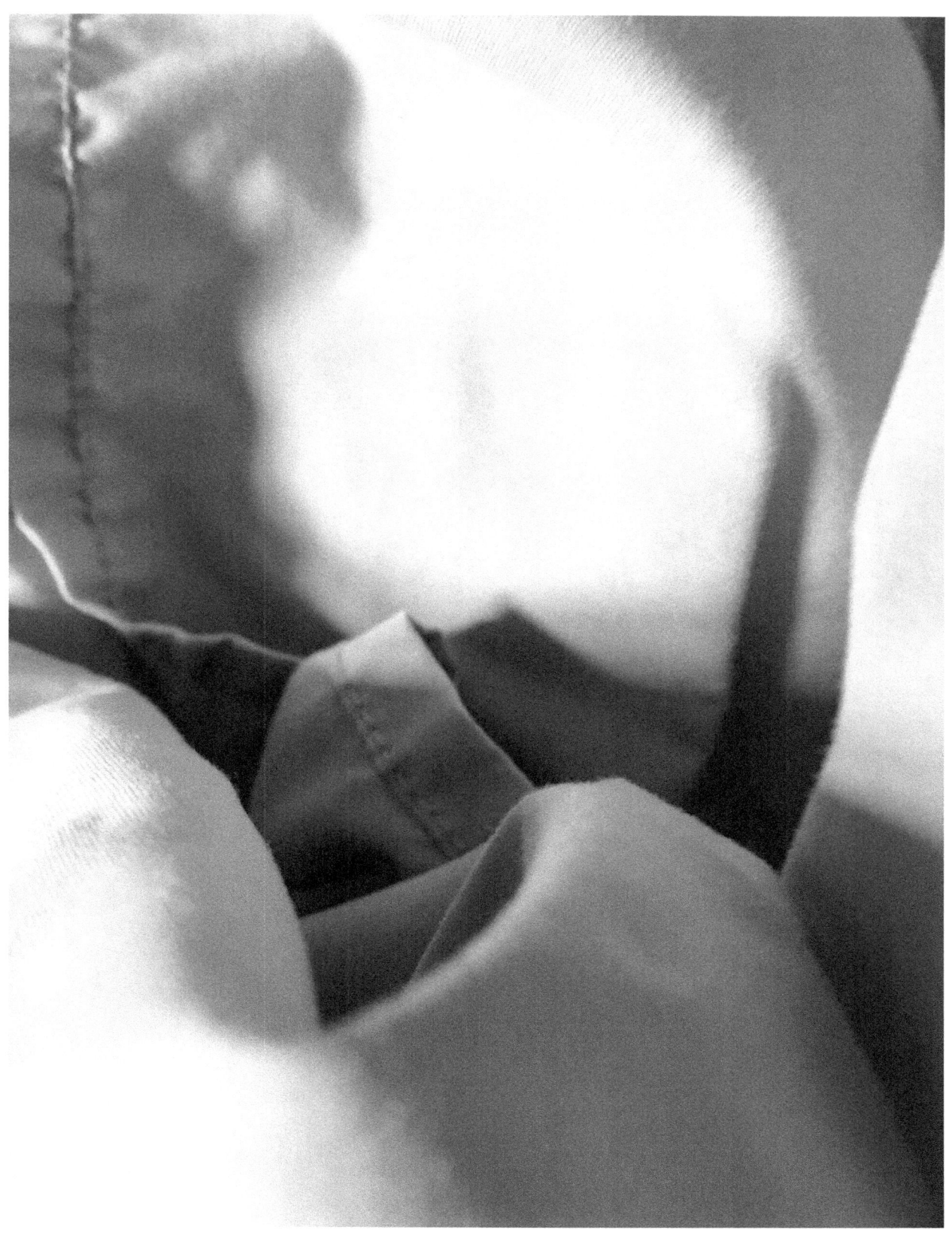

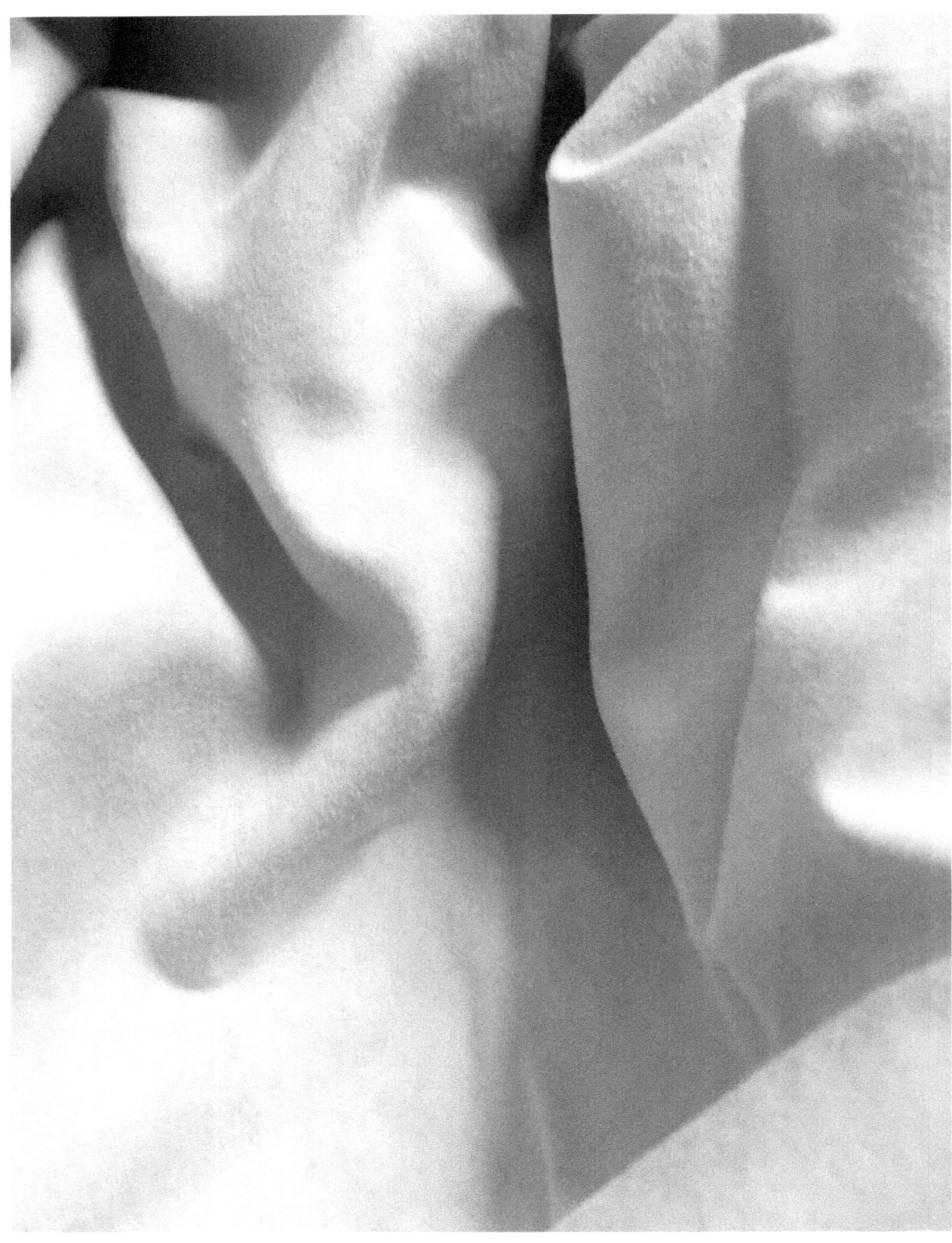

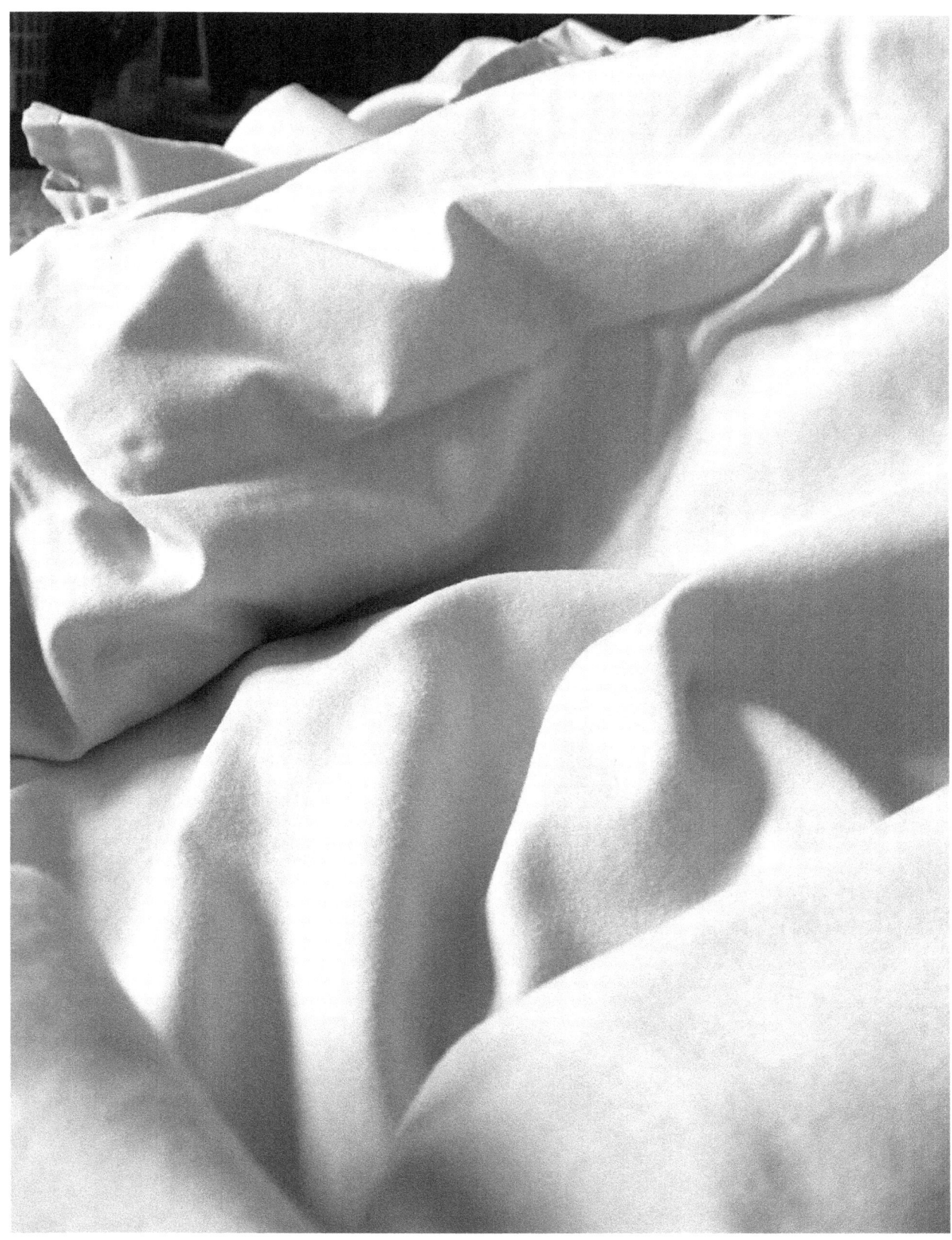

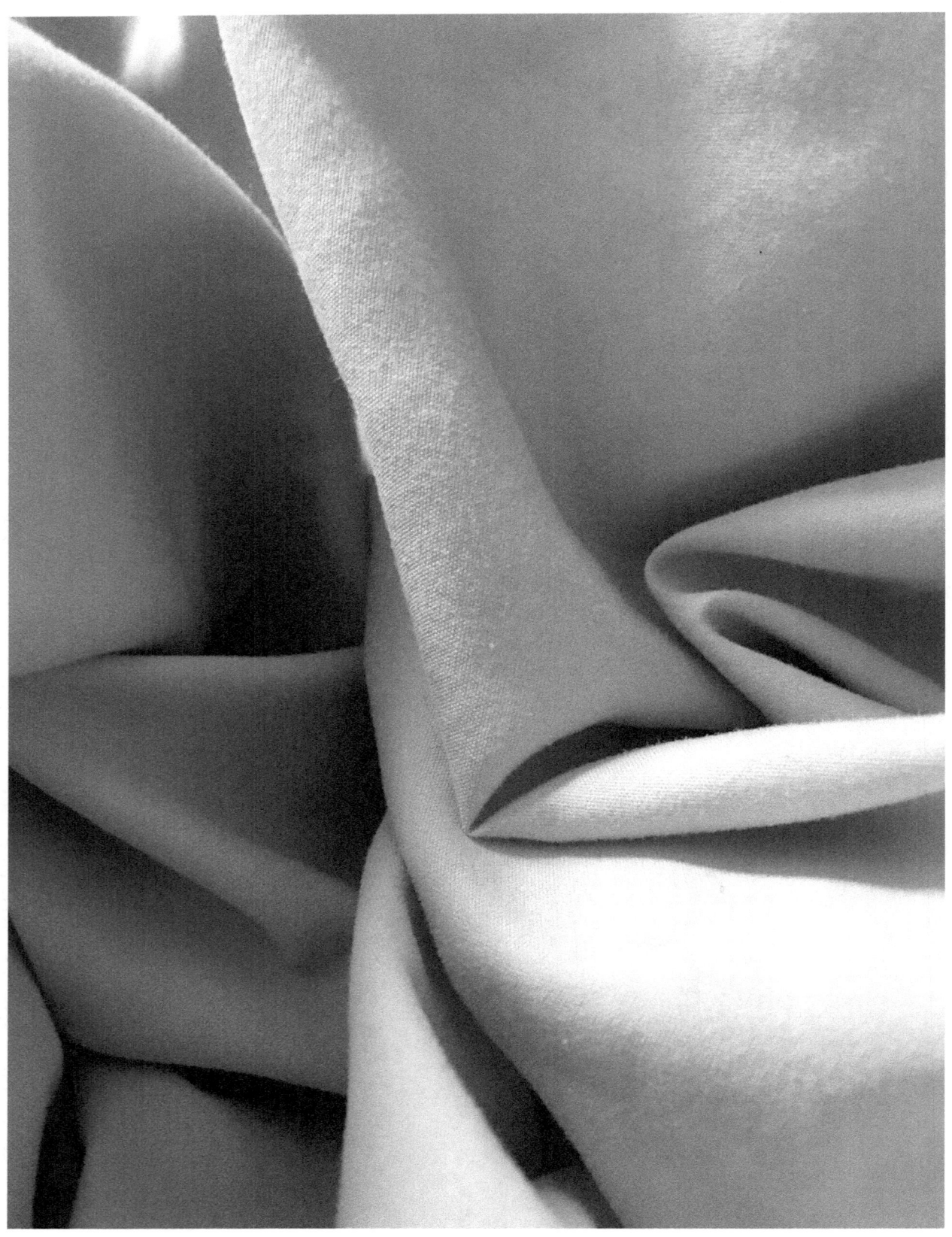

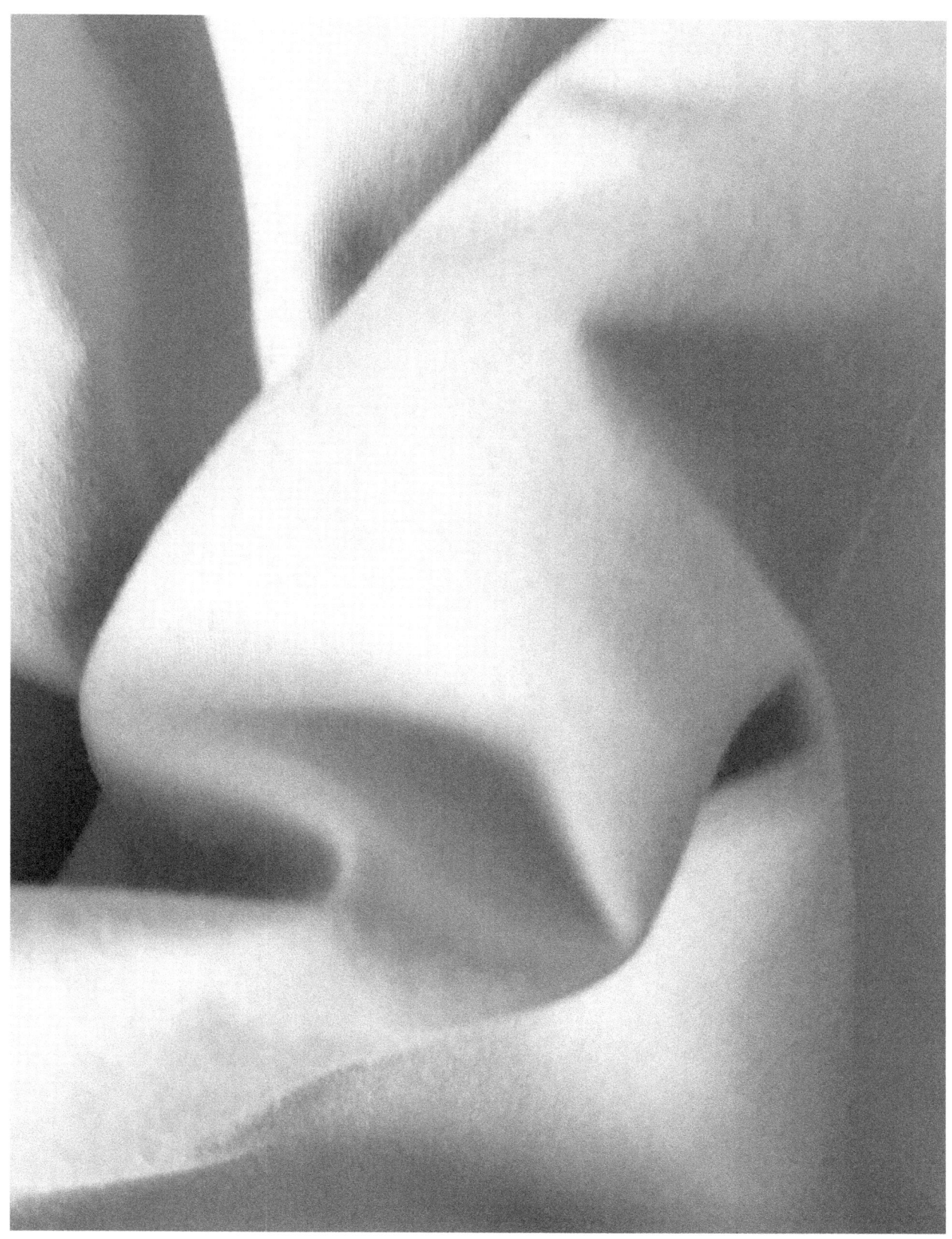

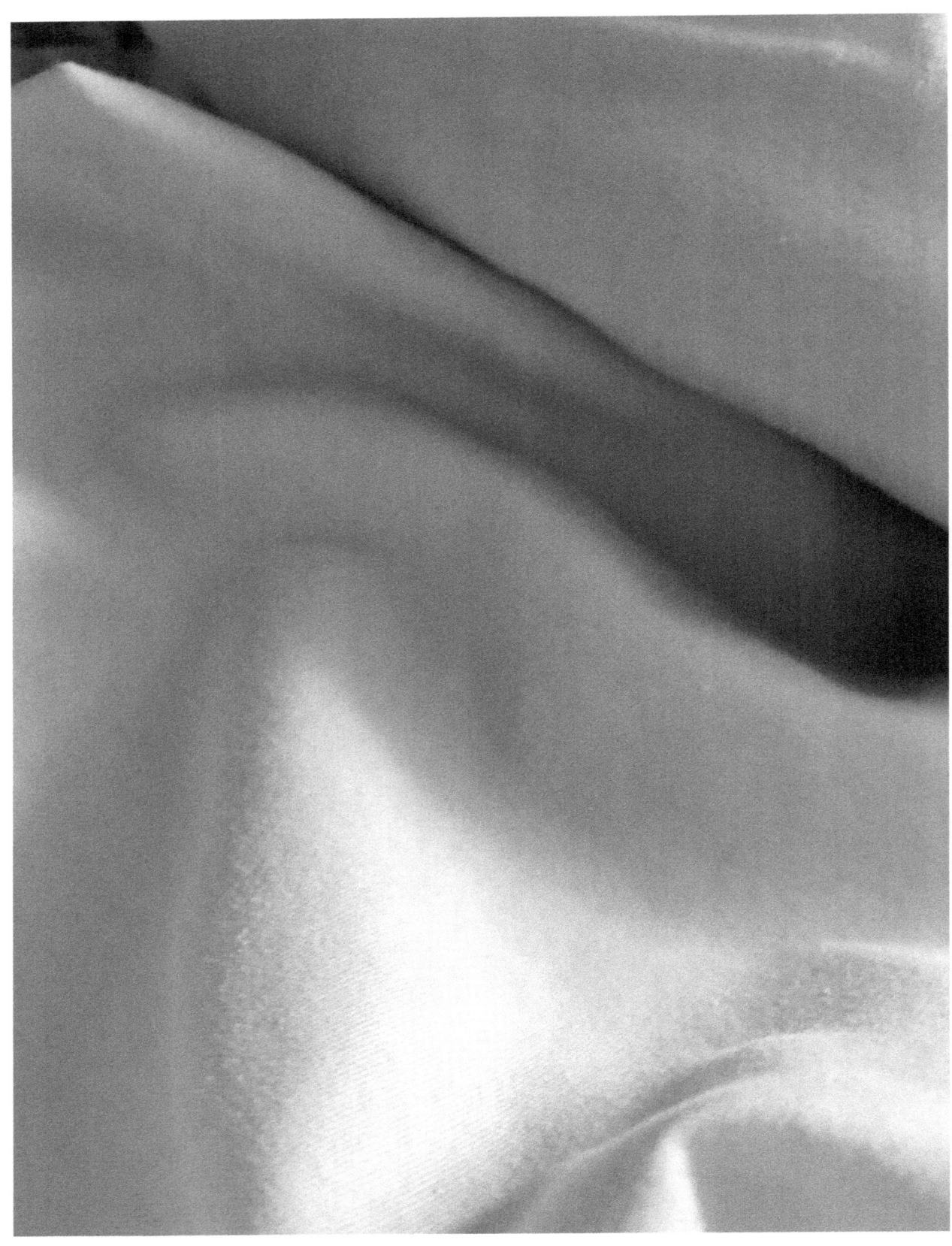

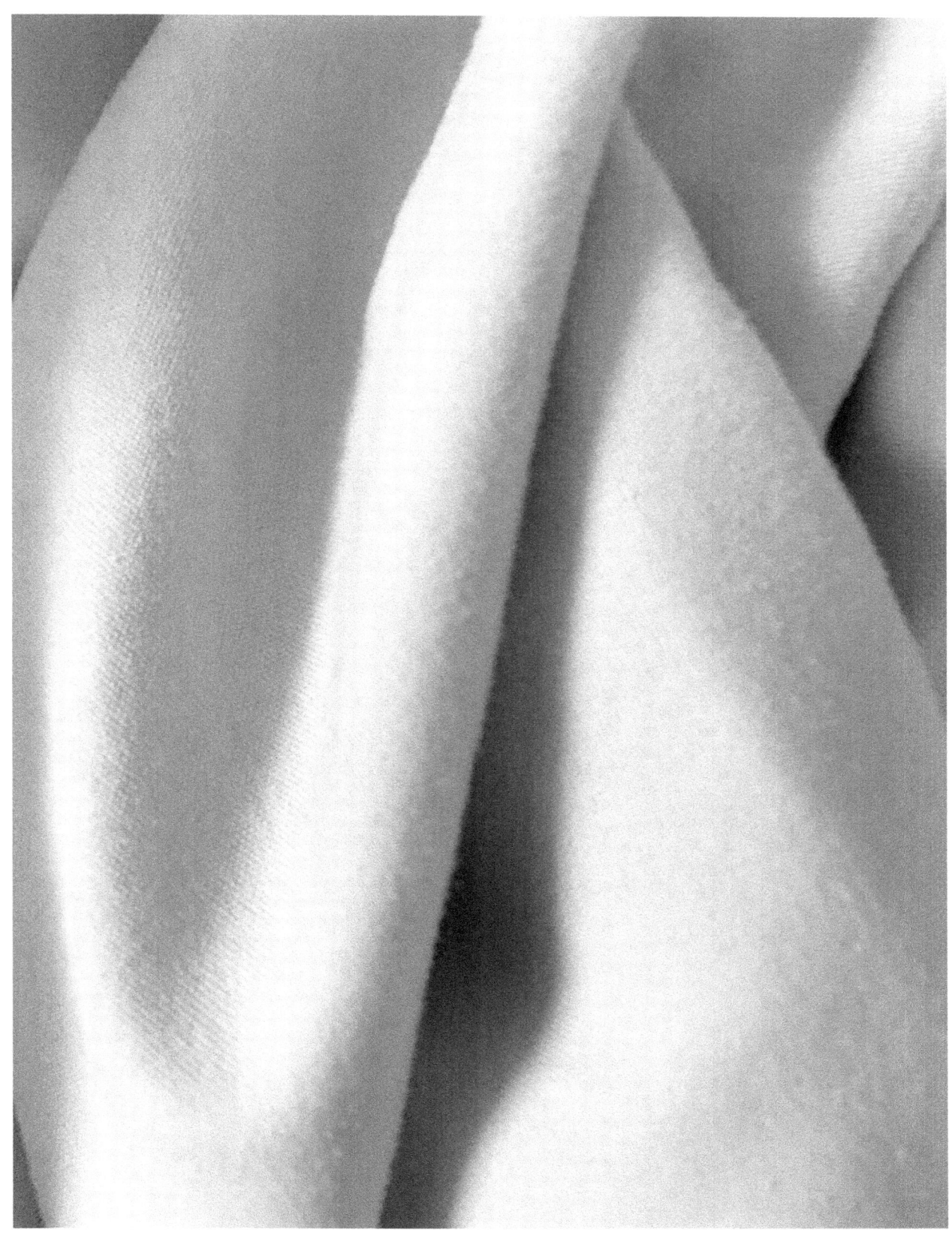

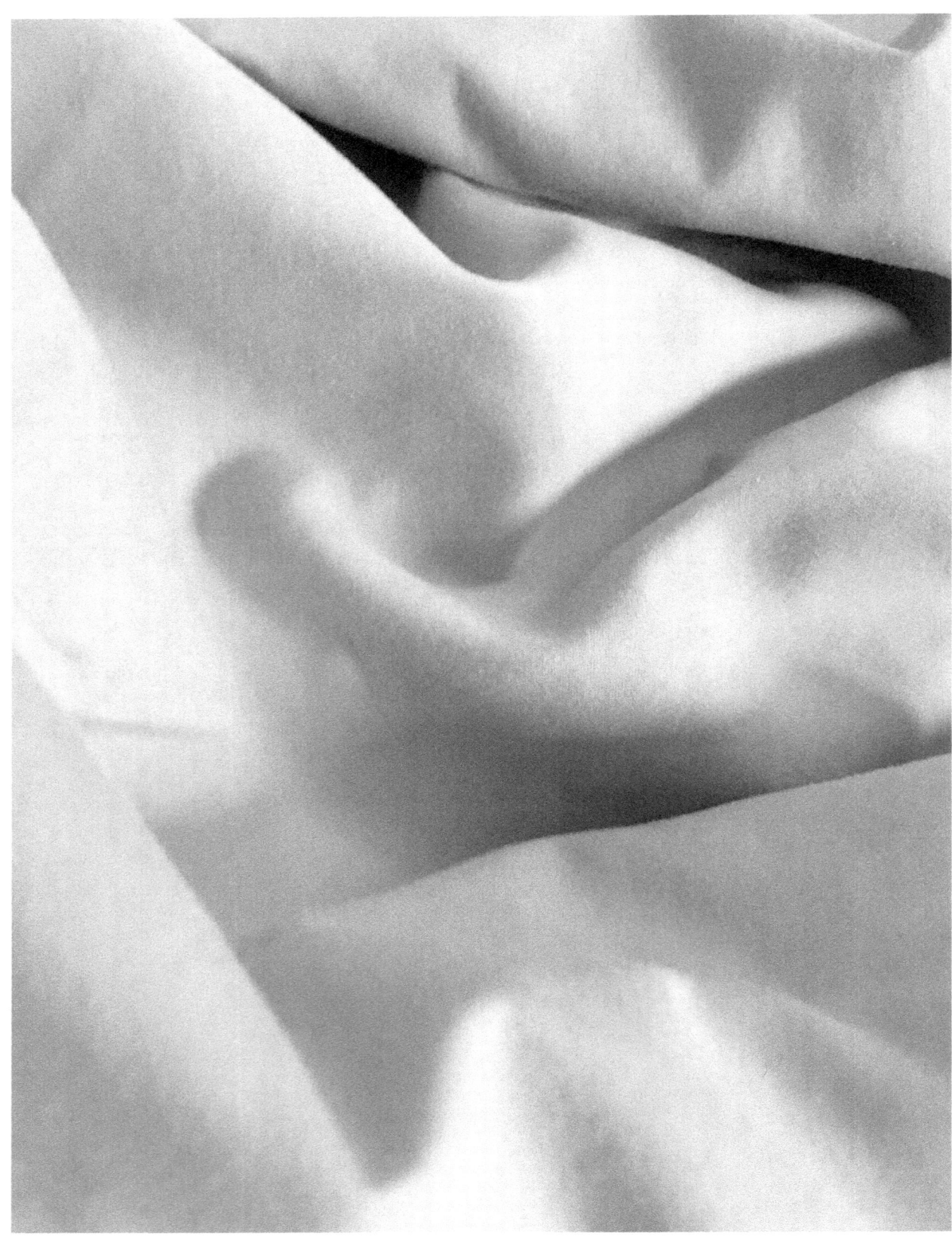

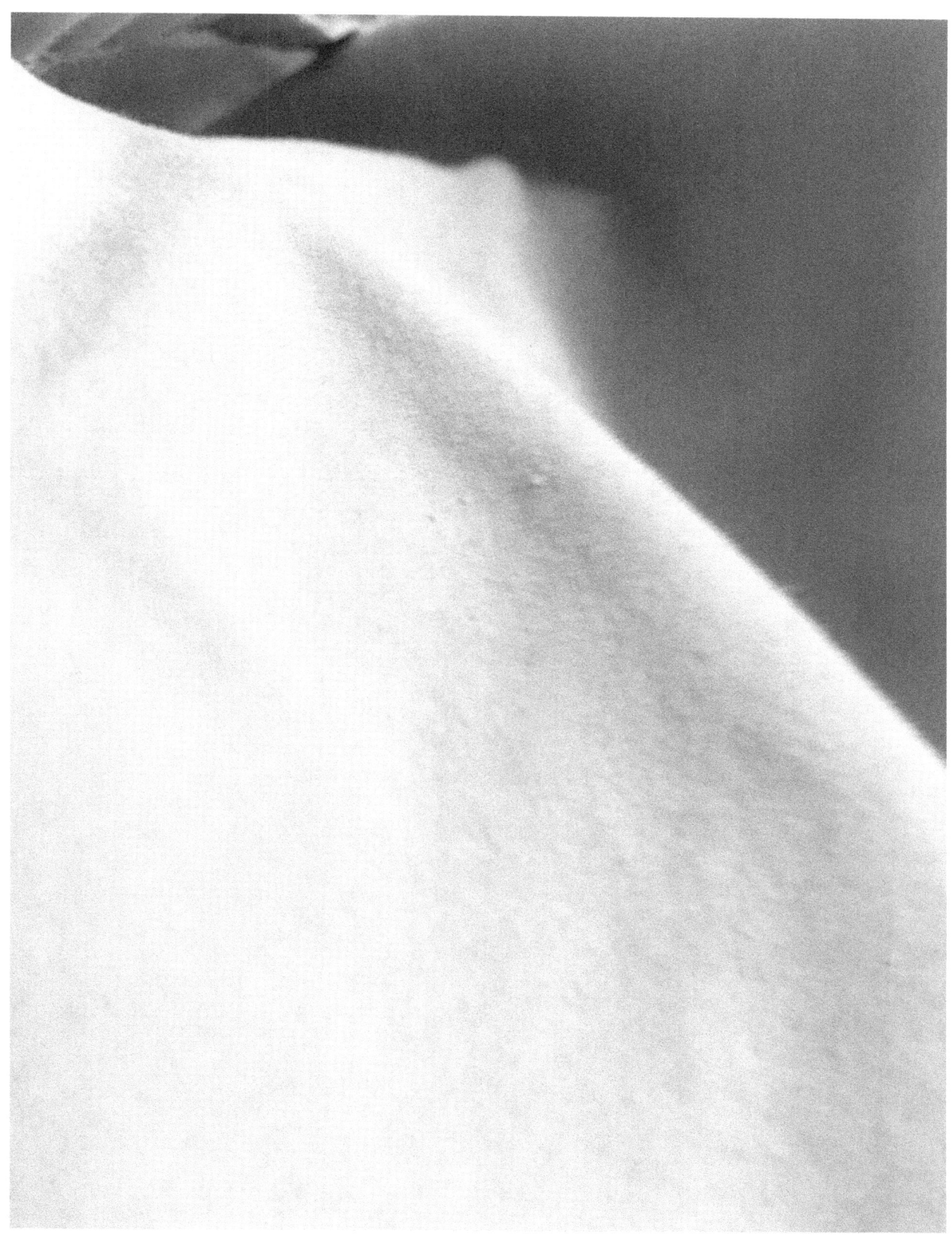

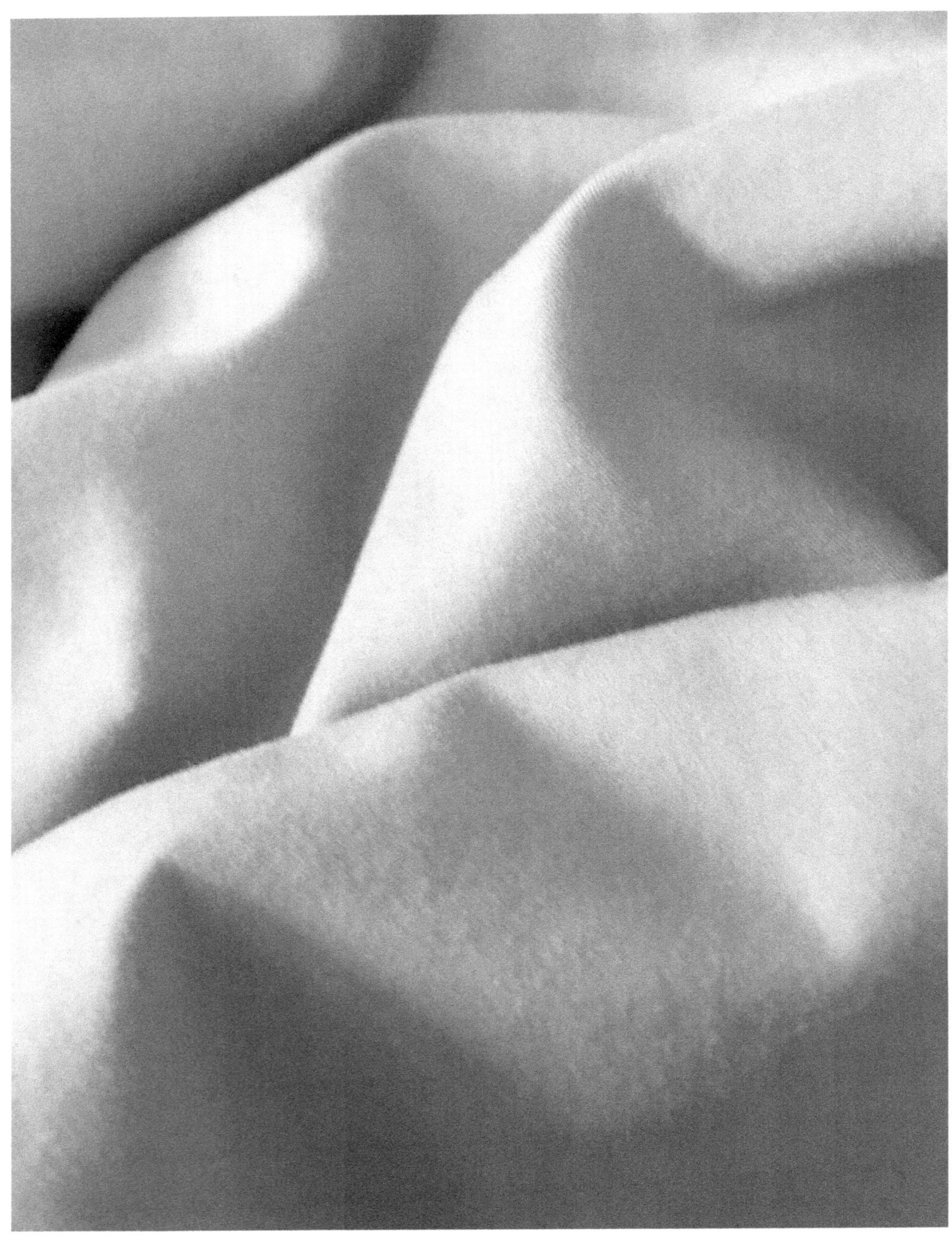

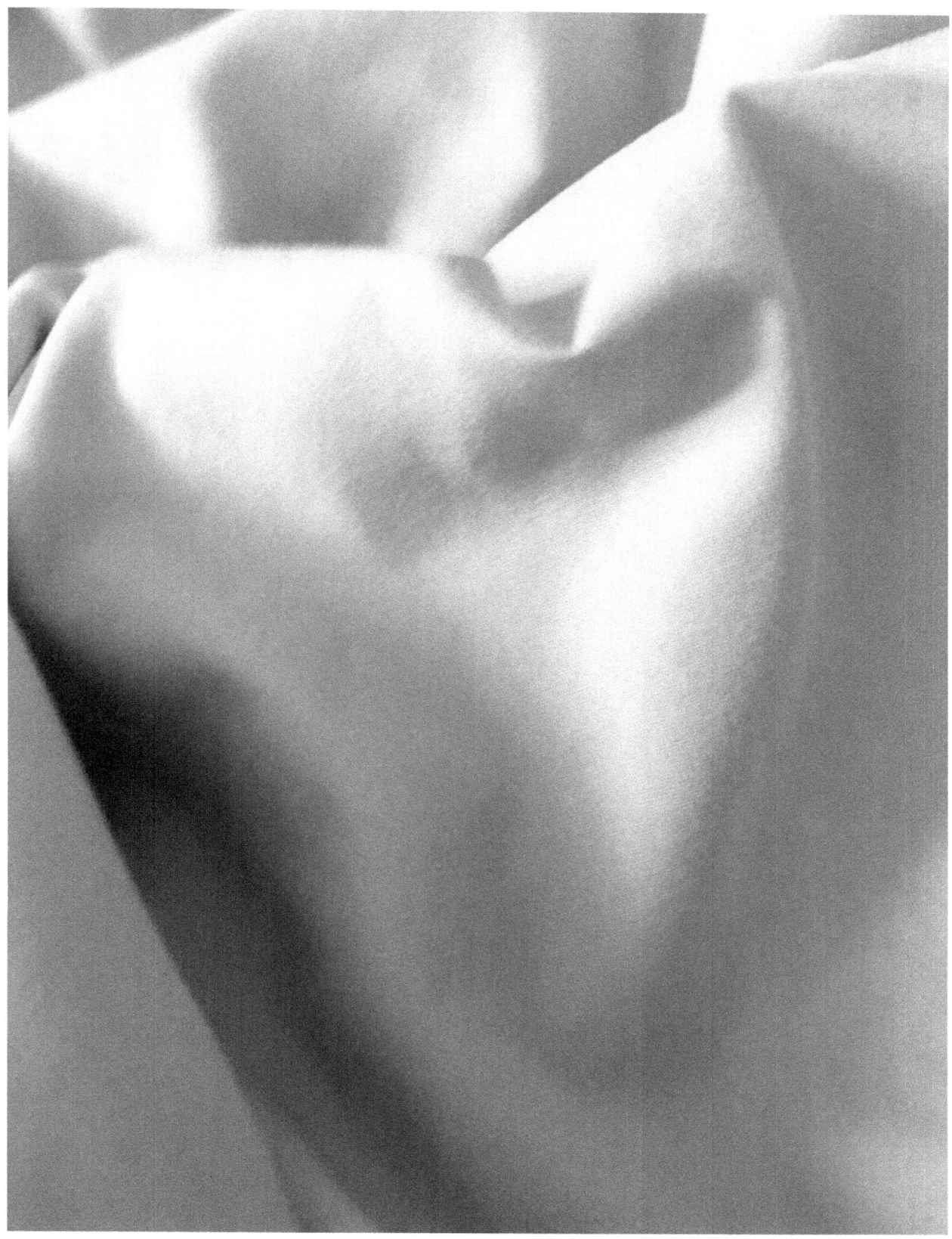

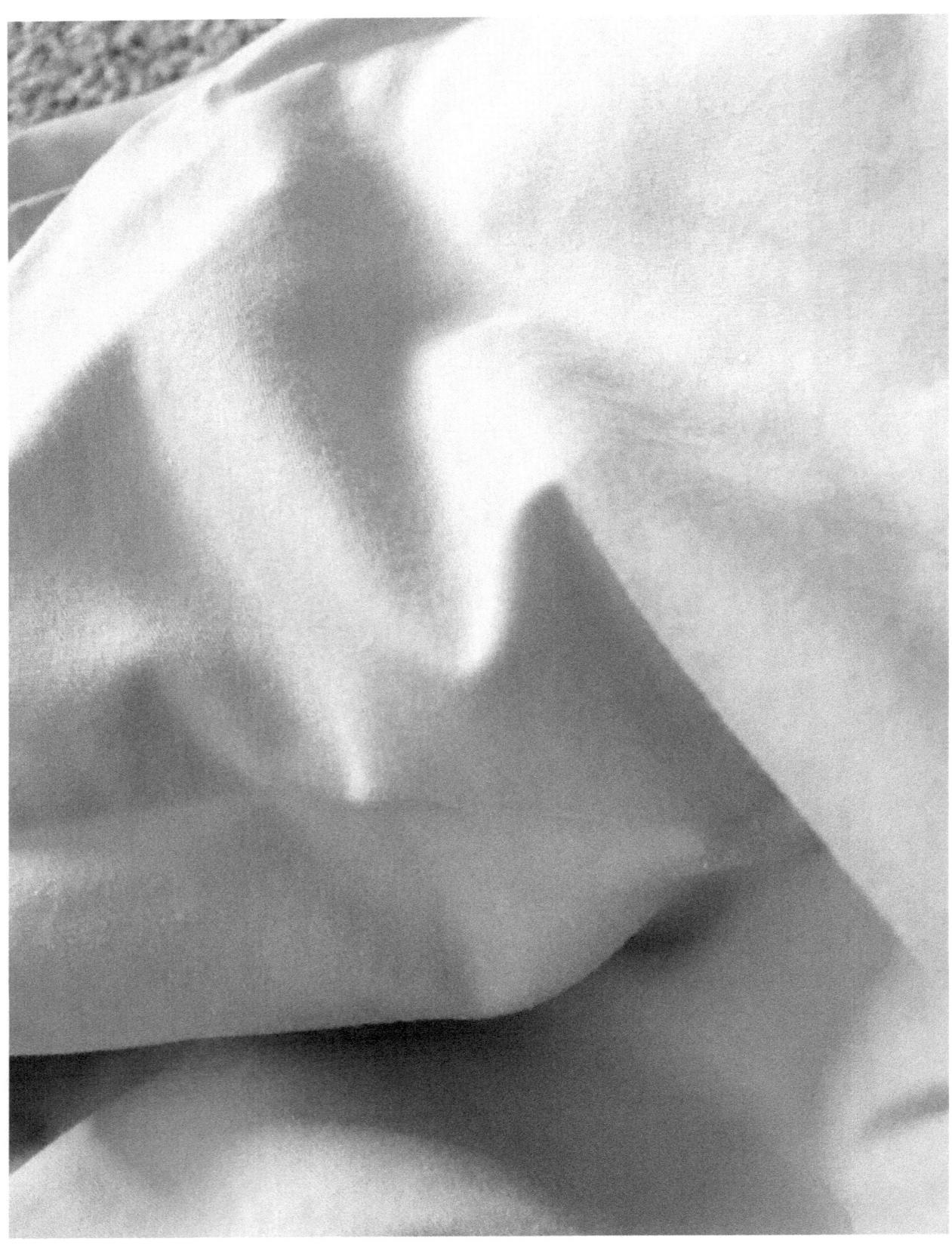

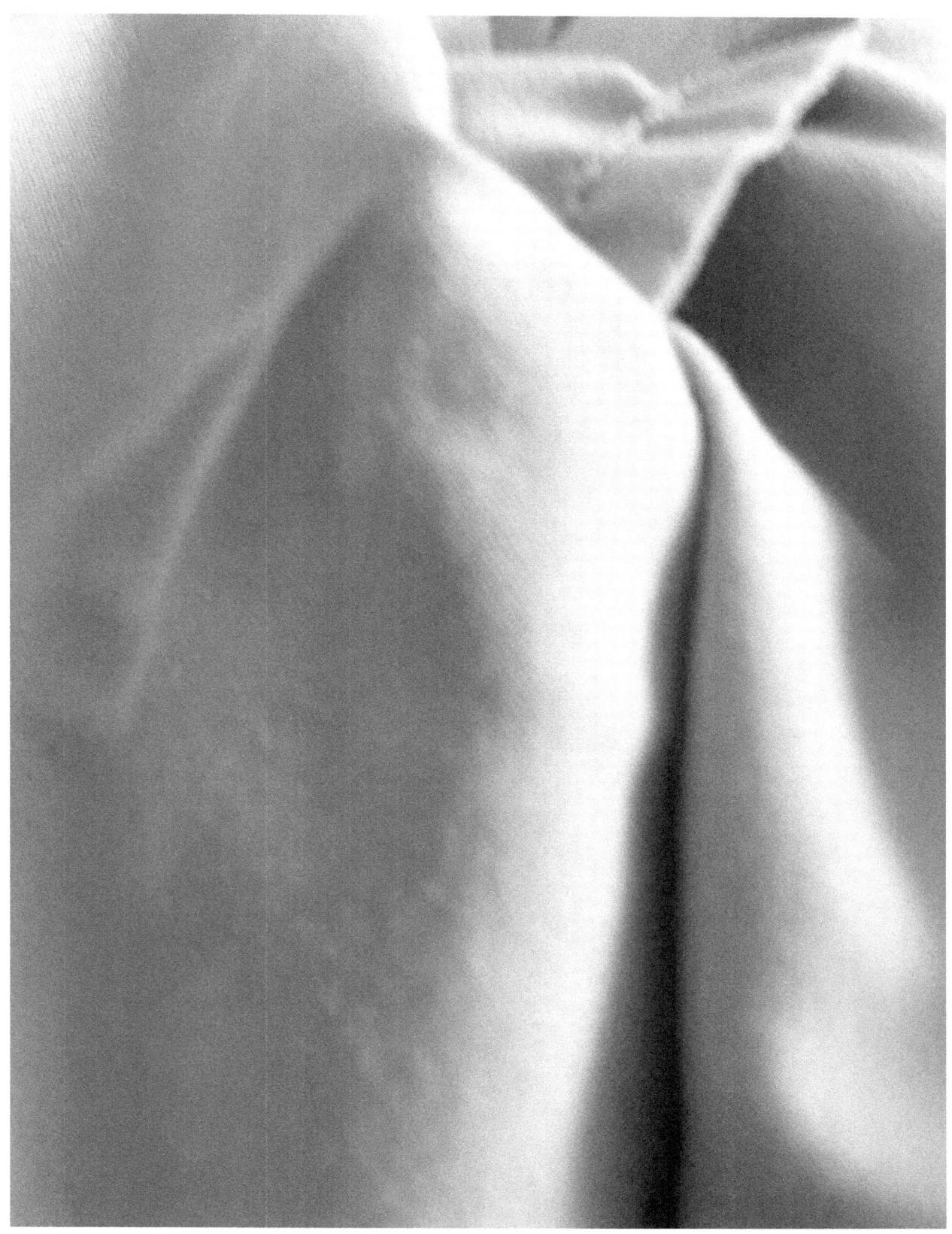

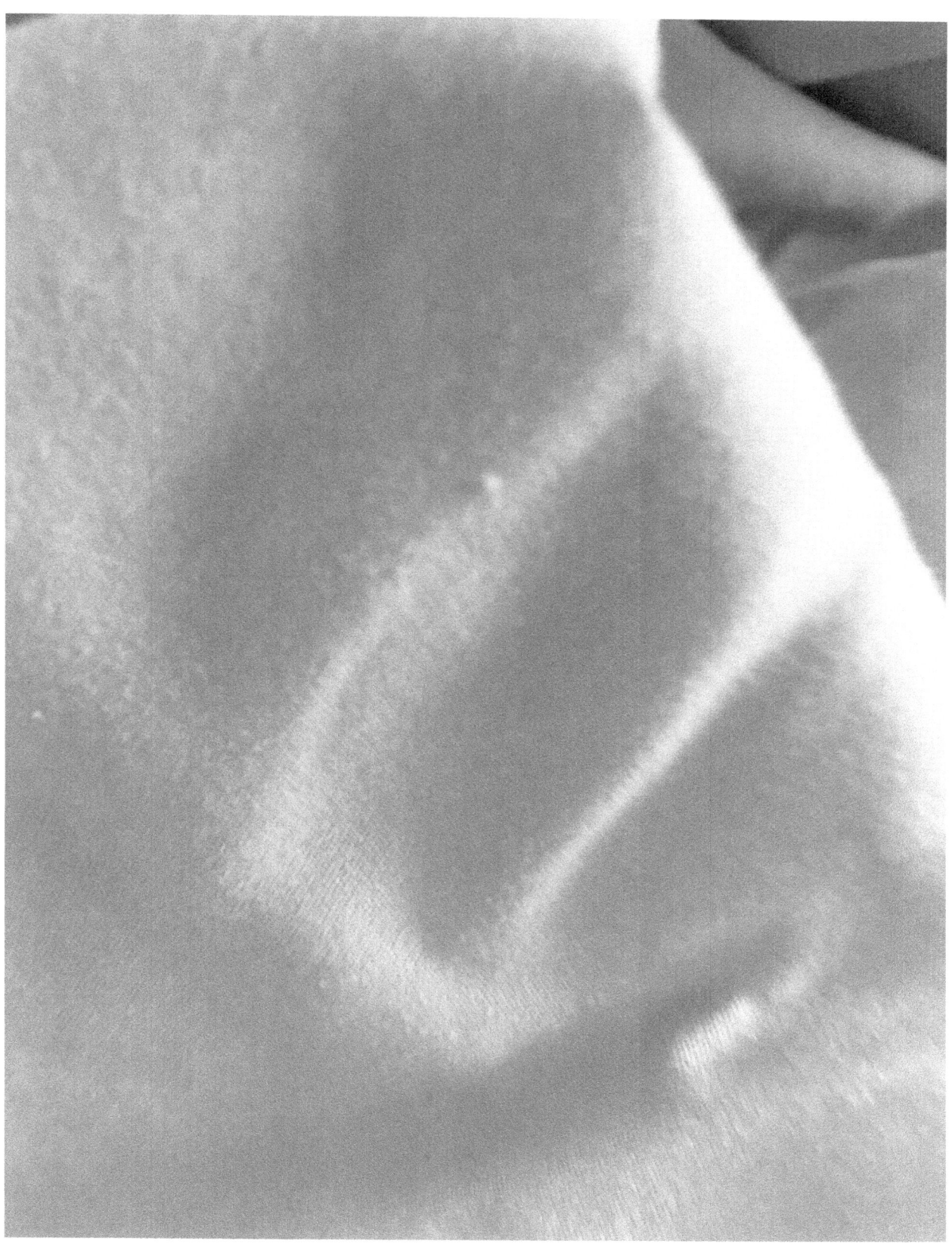

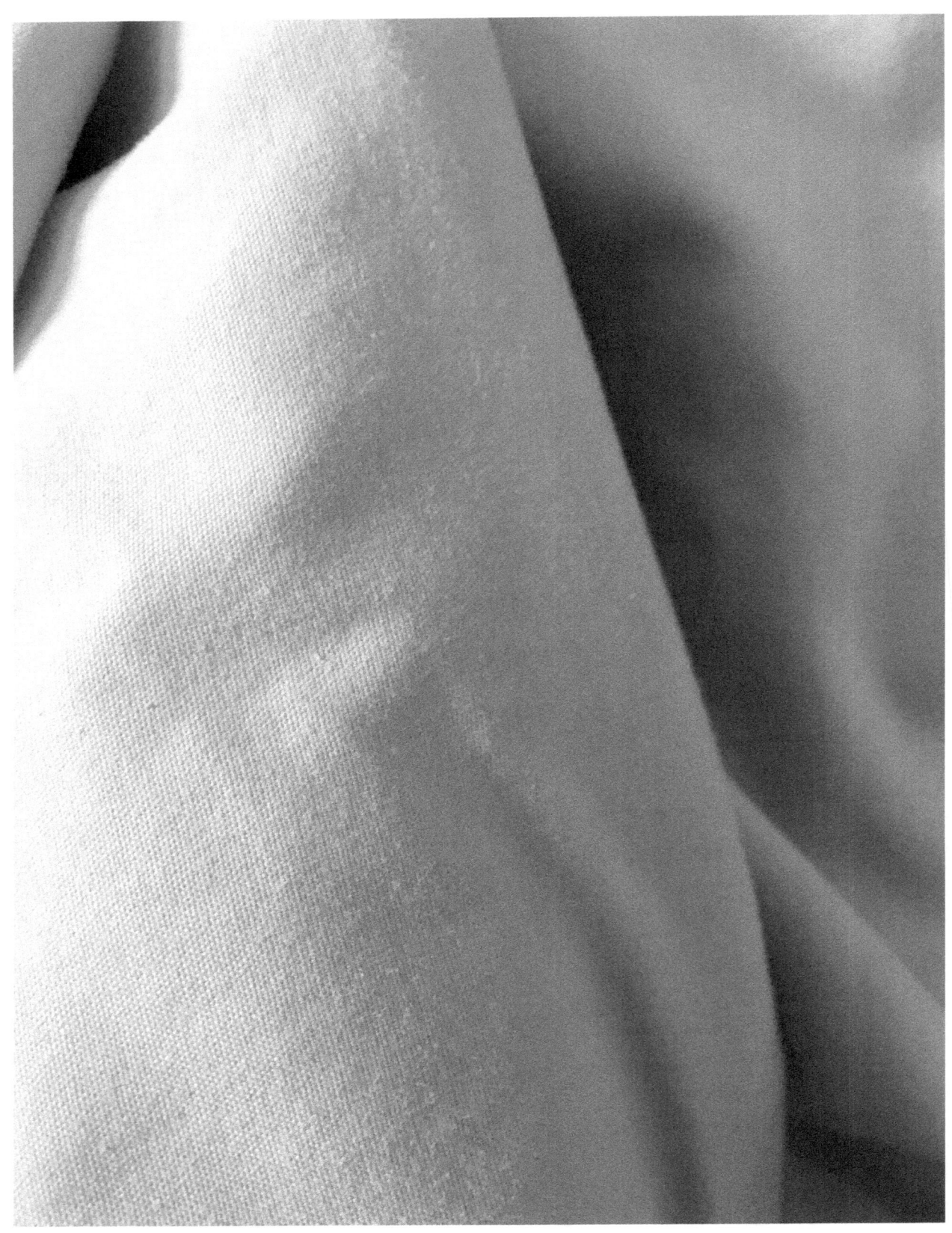

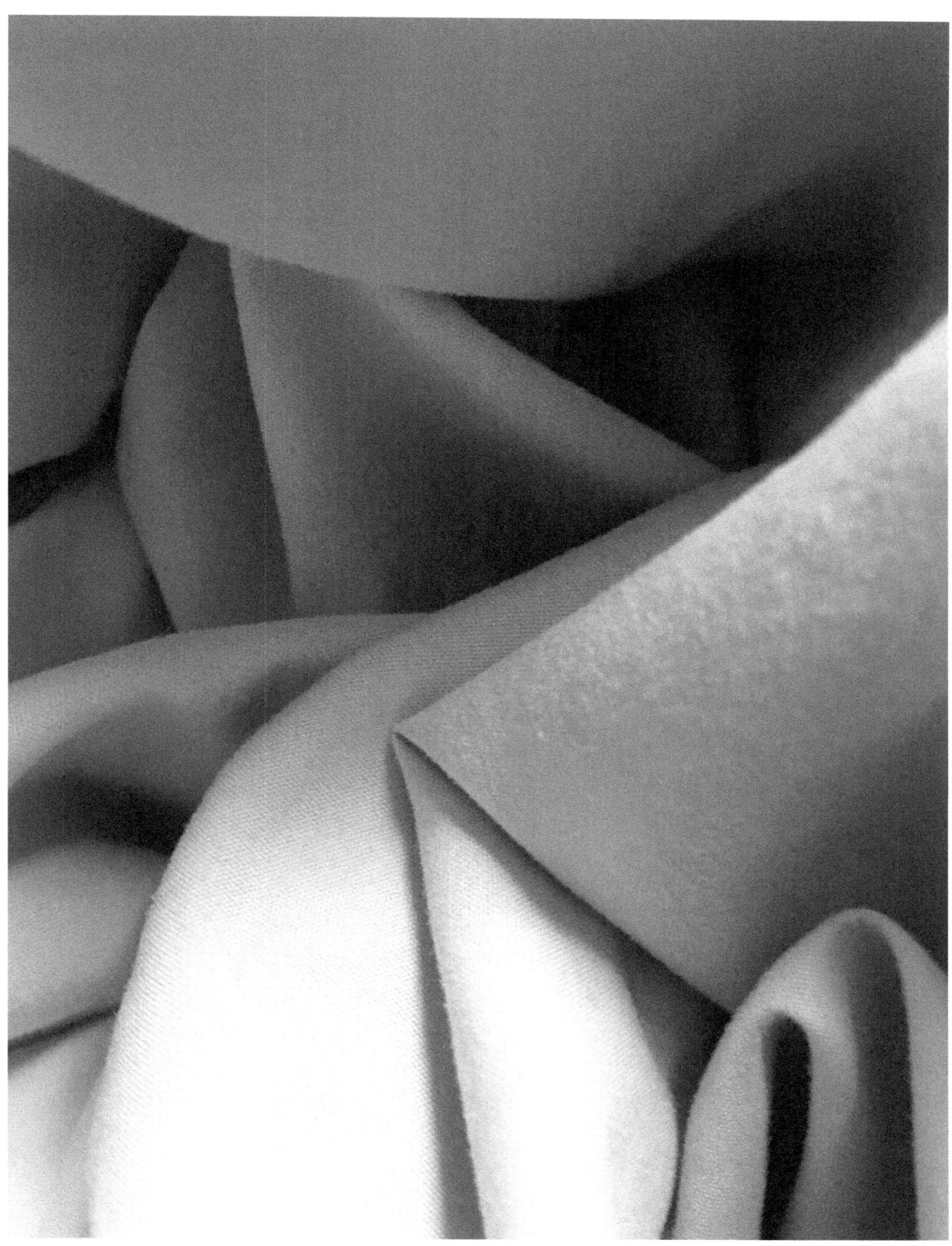

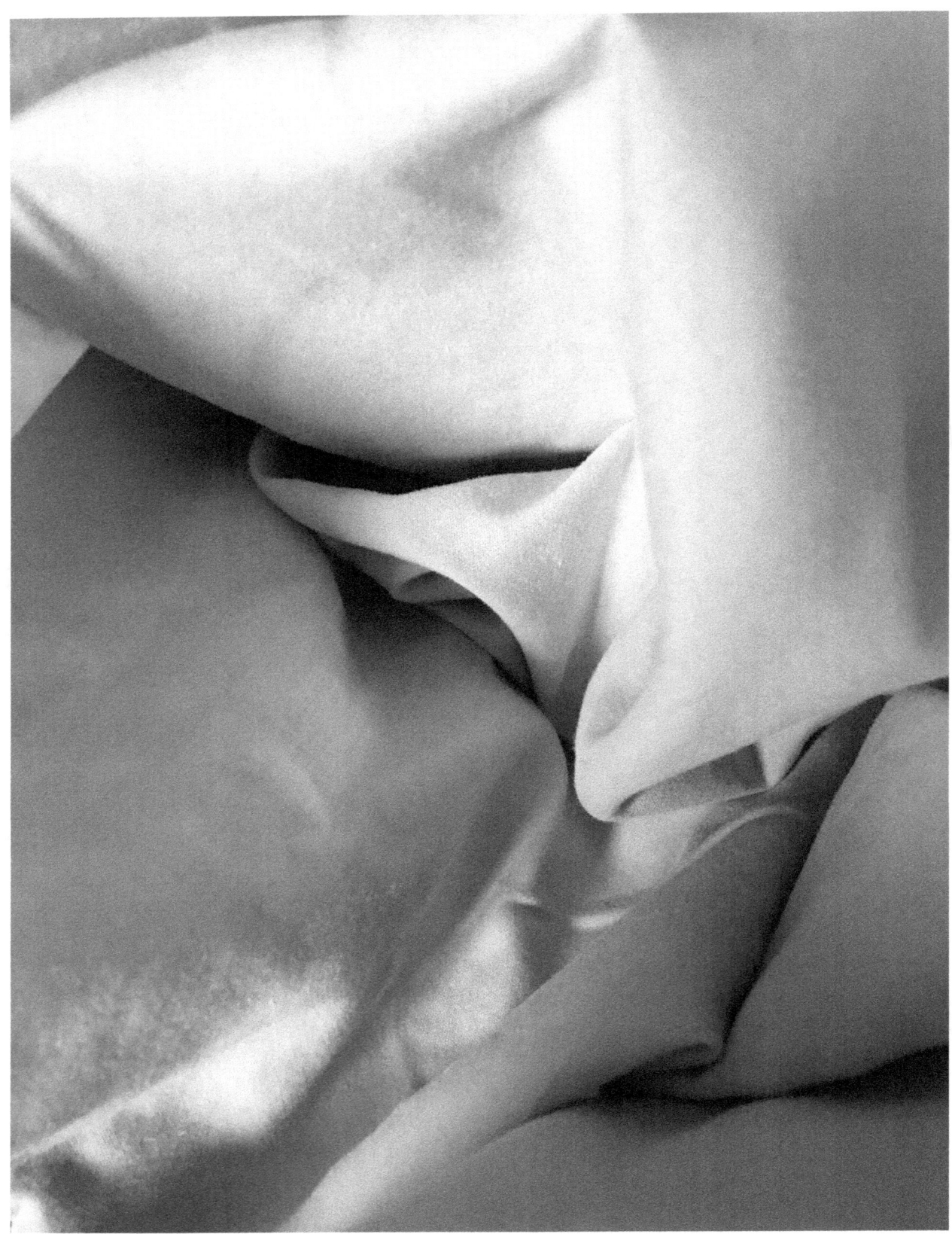

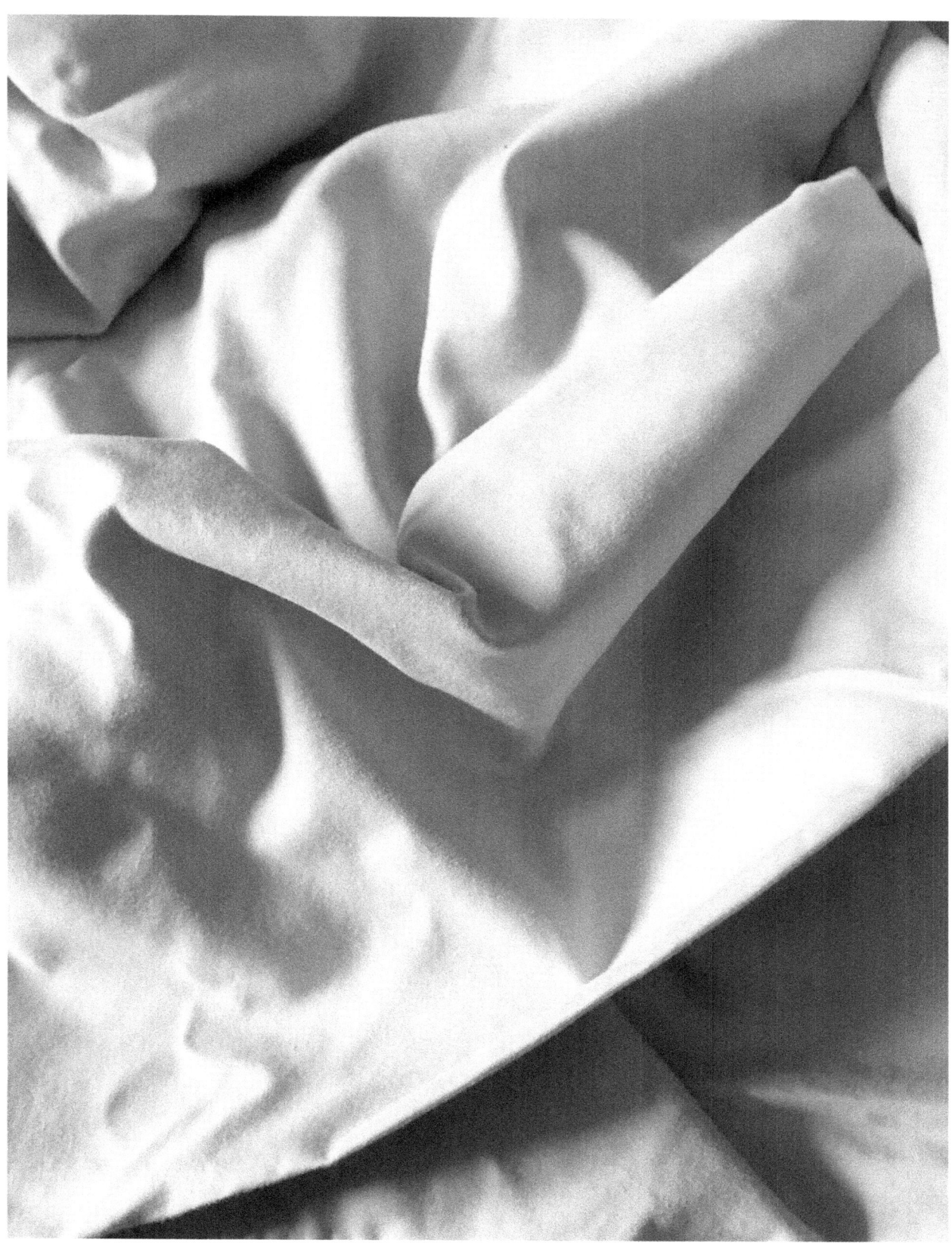

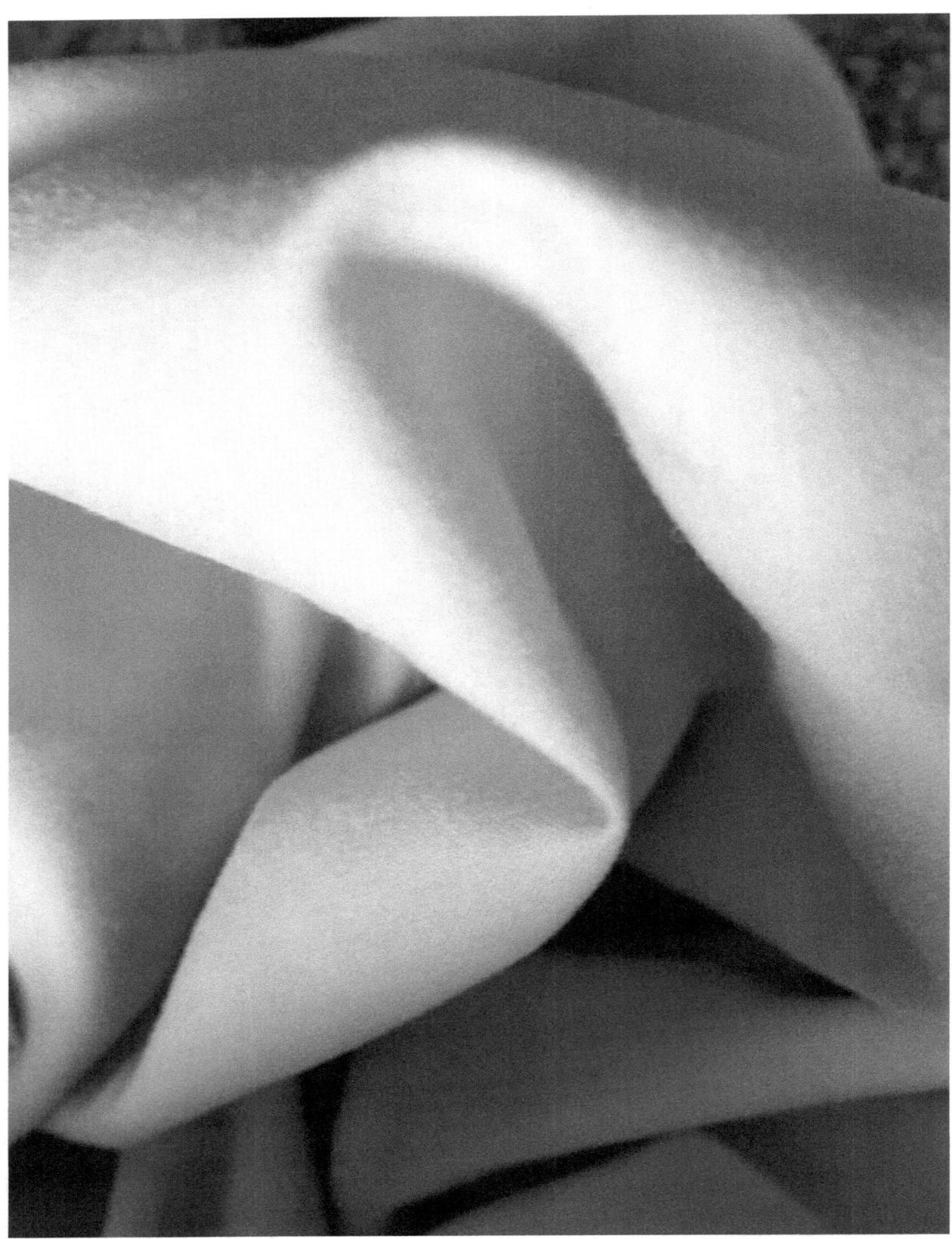

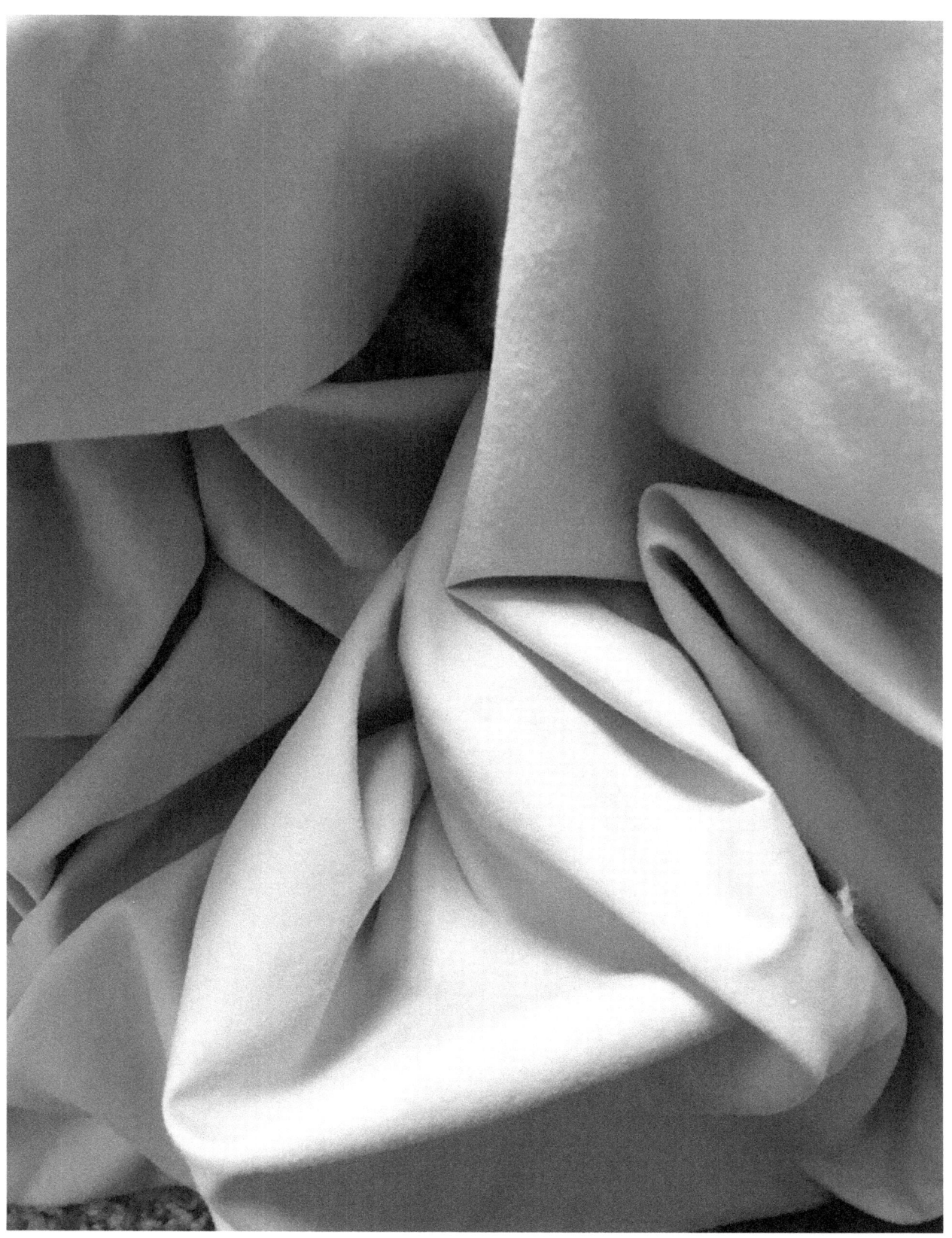

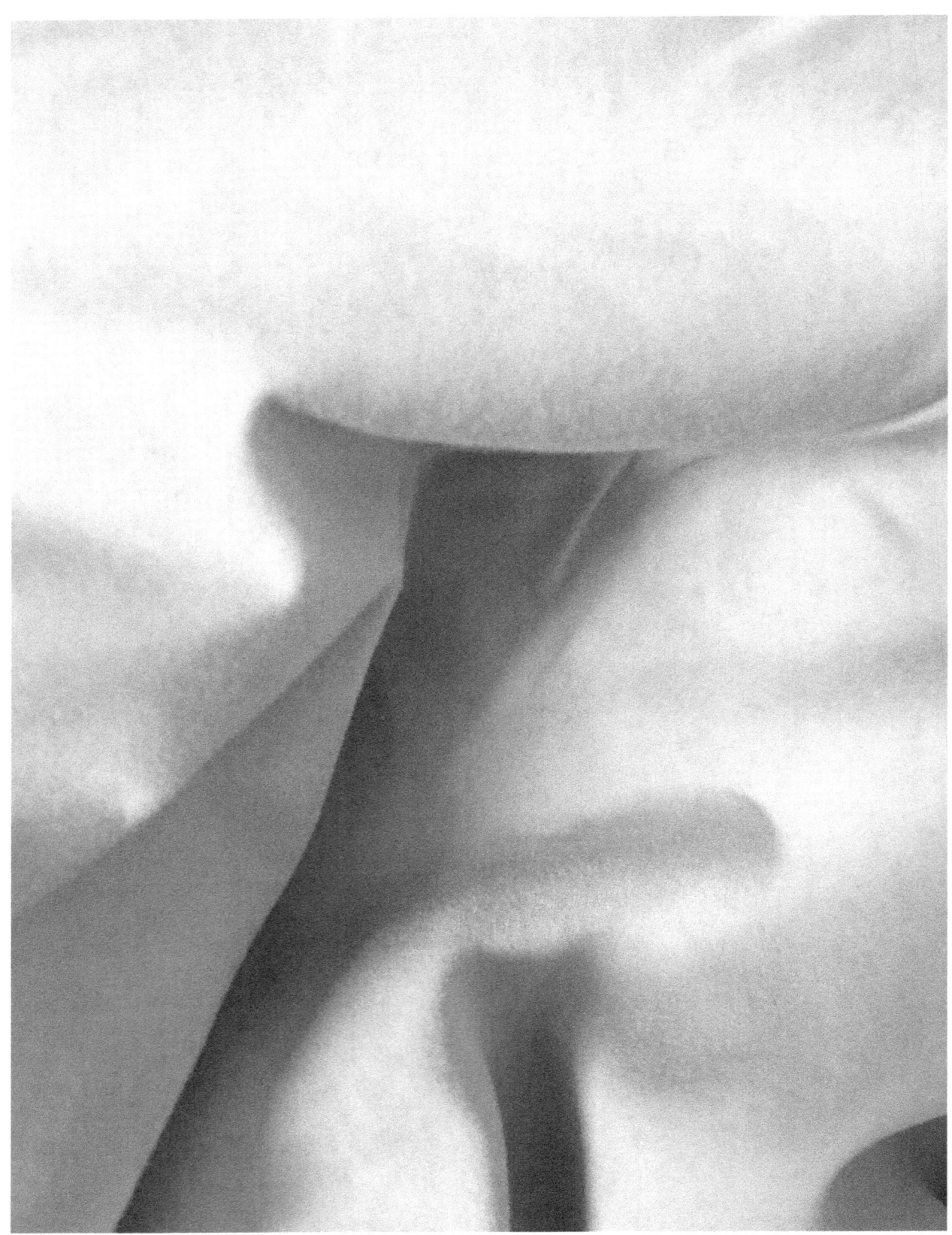

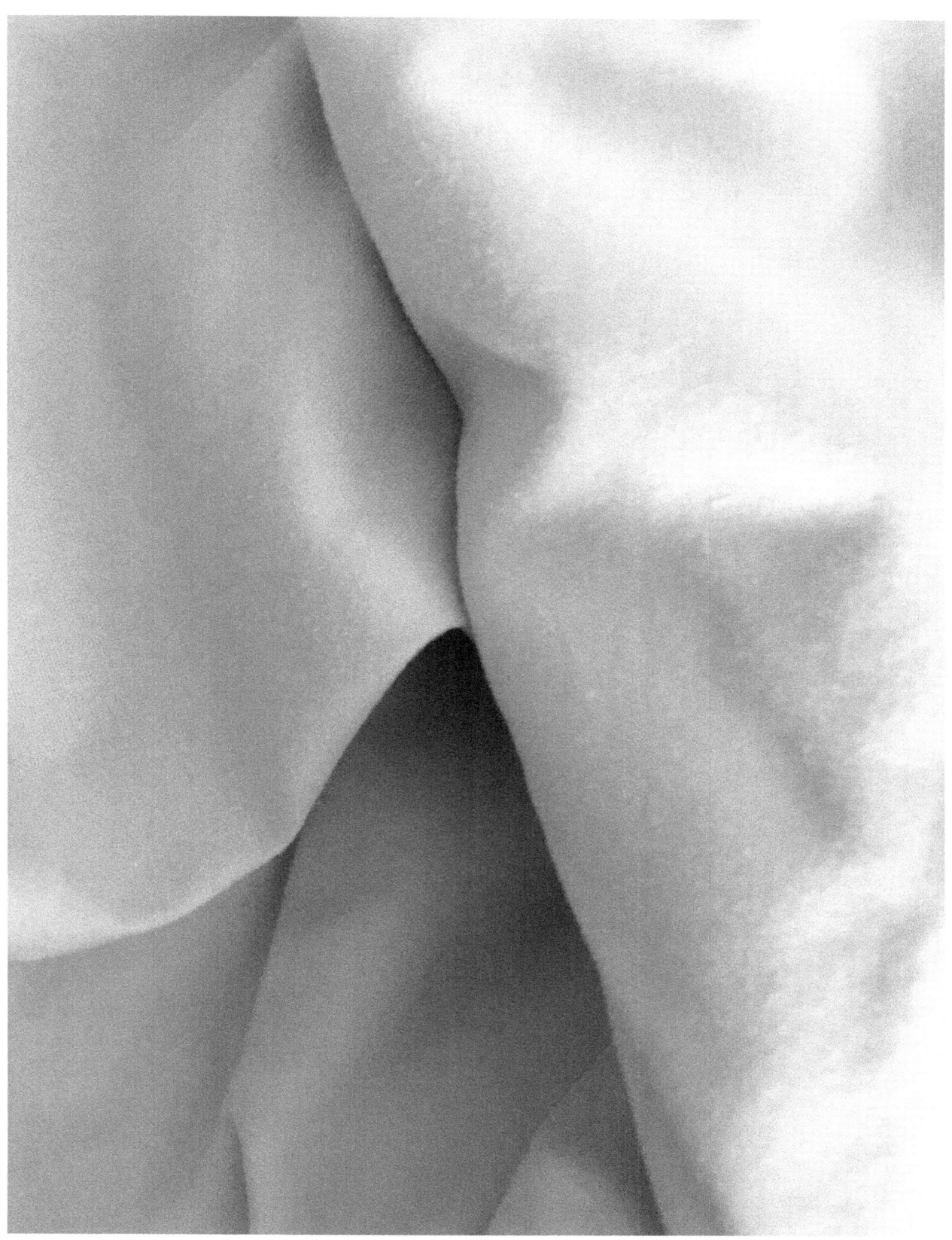

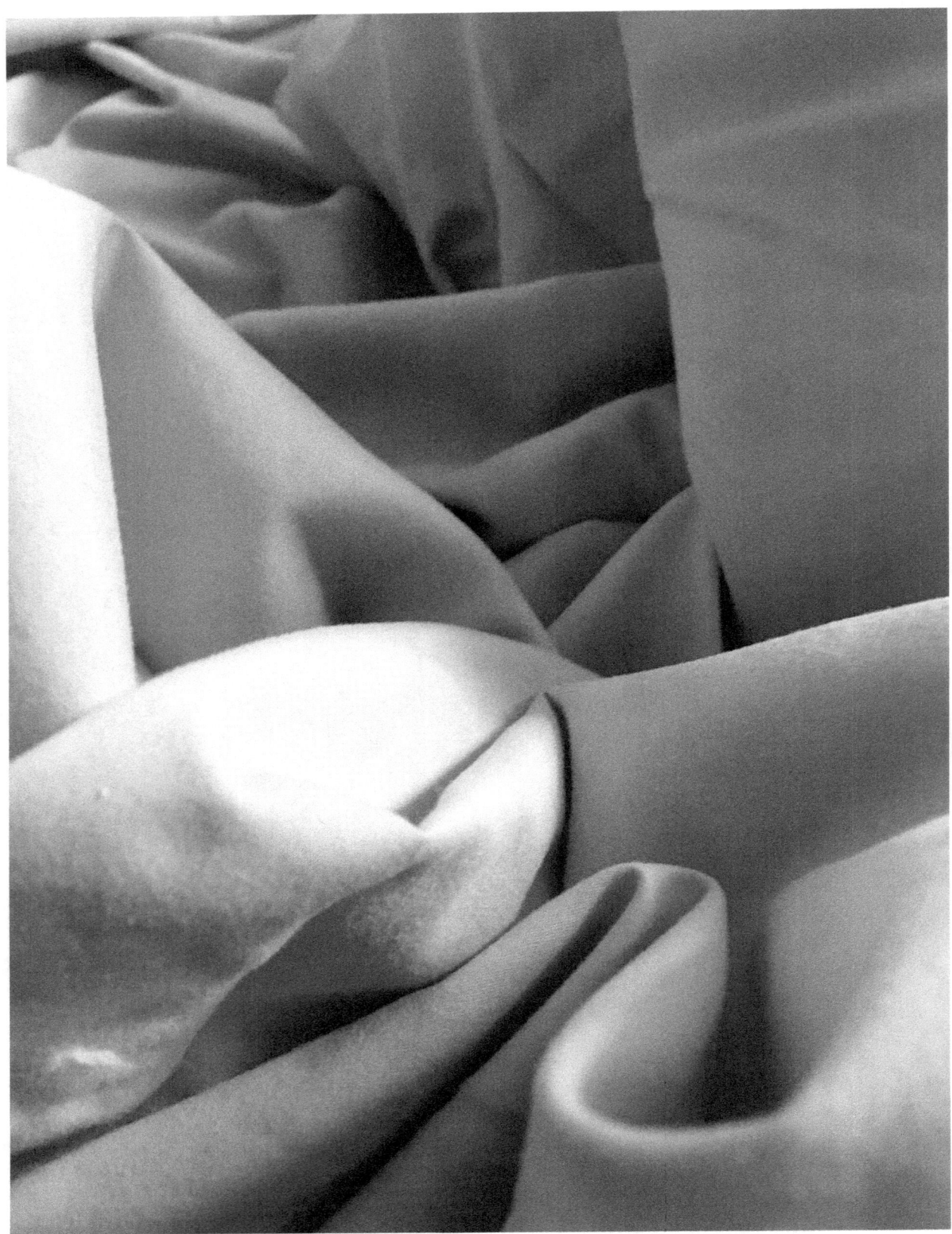

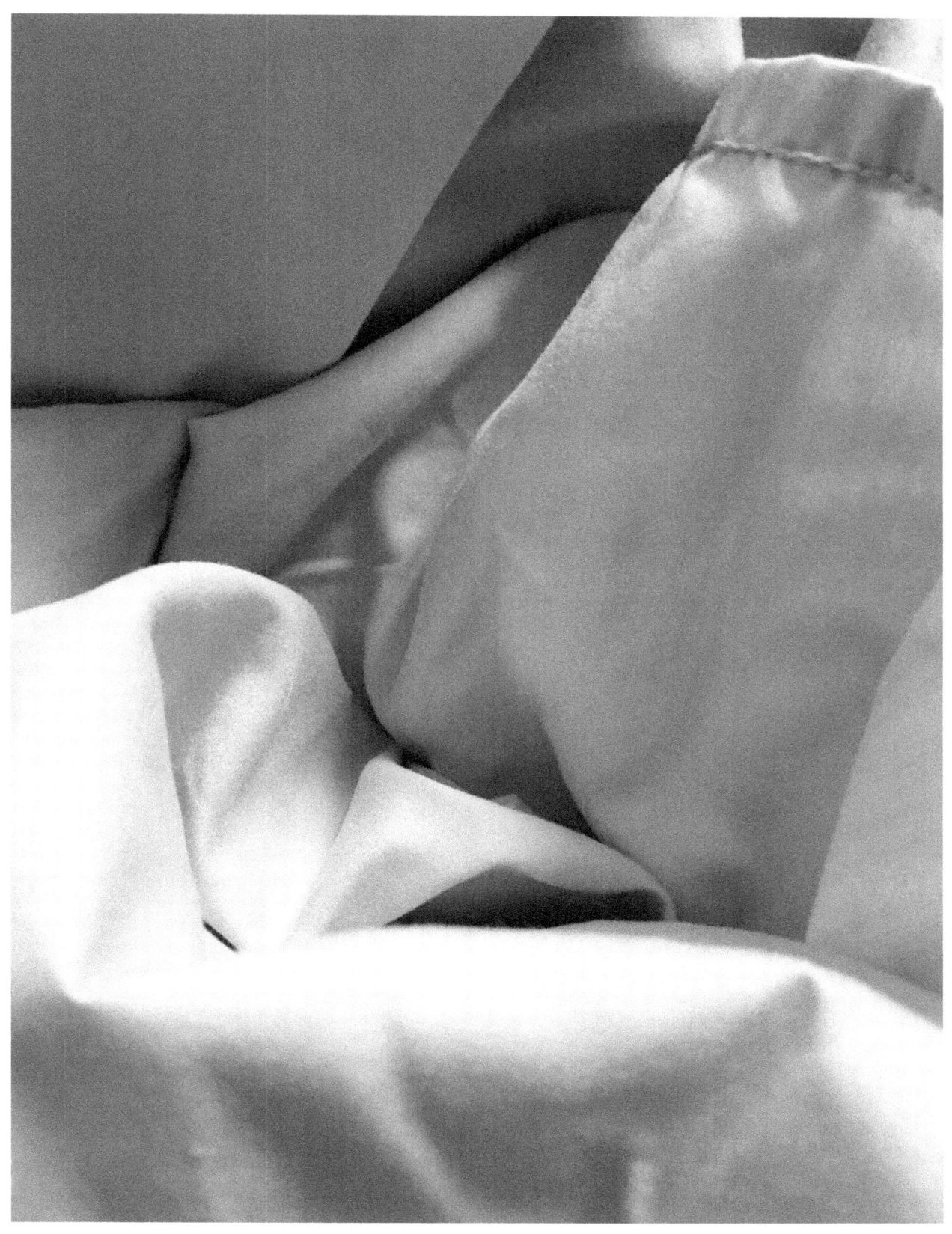

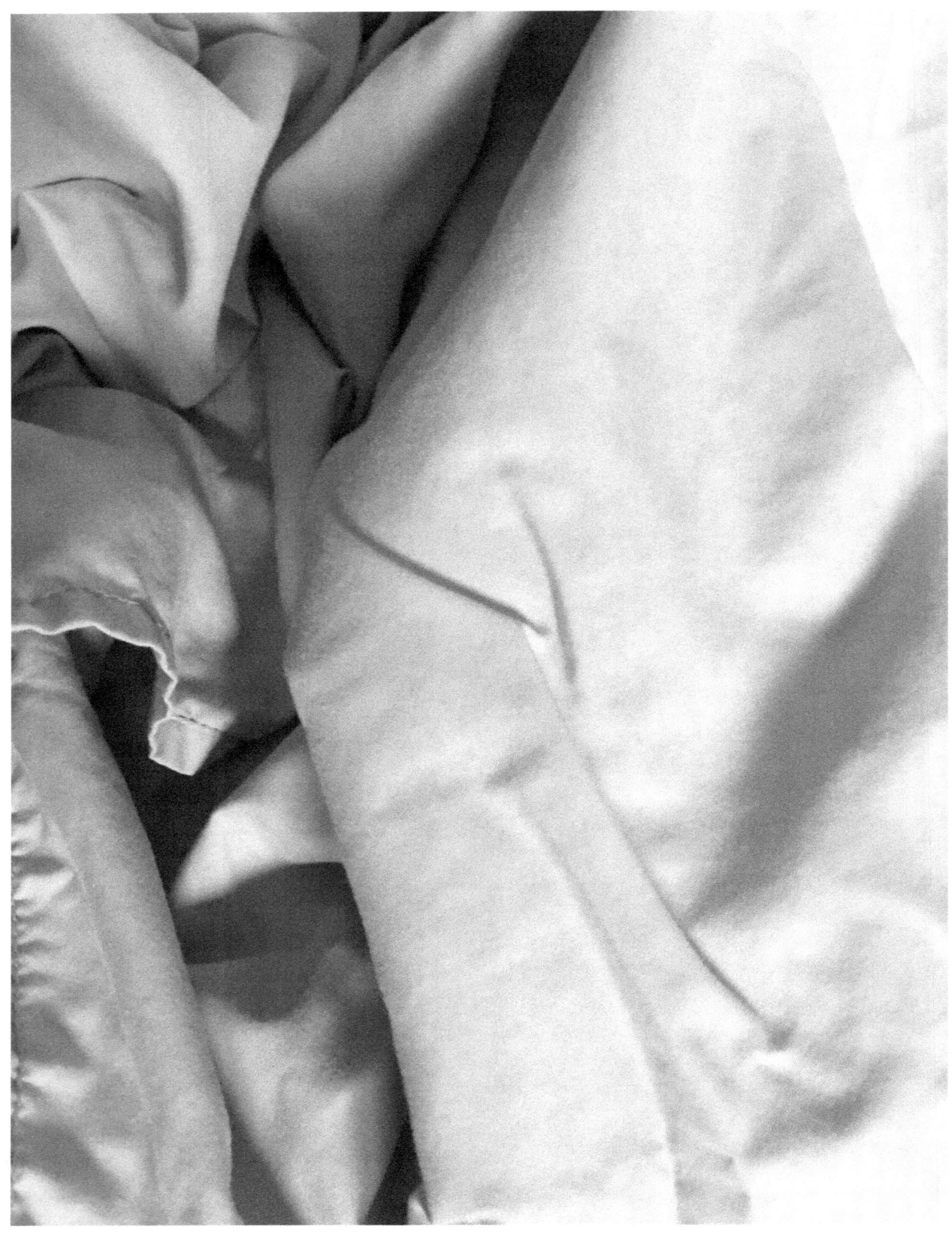

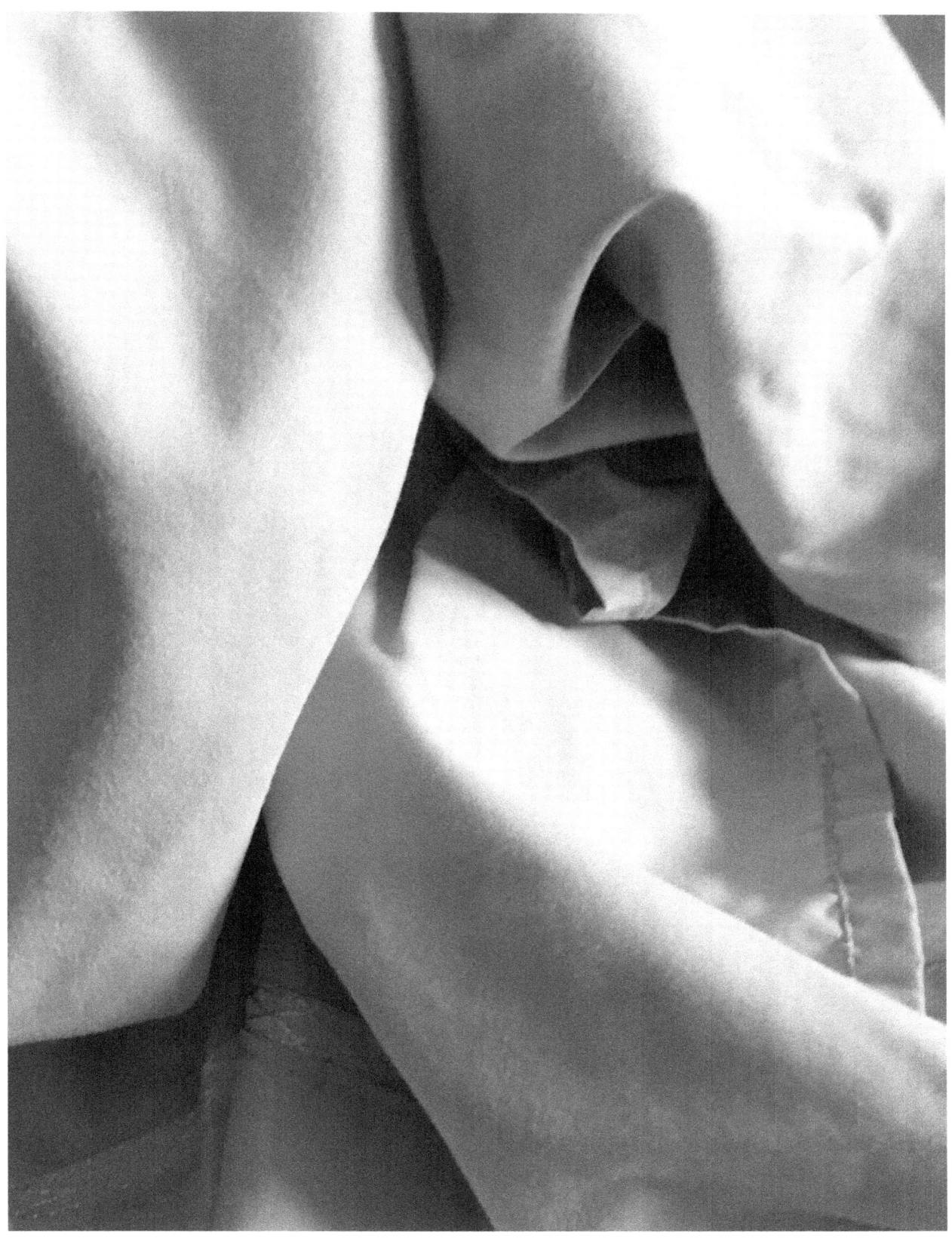